Tom Thomson: Trees

Tom Thomson

Trees

Joan Murray

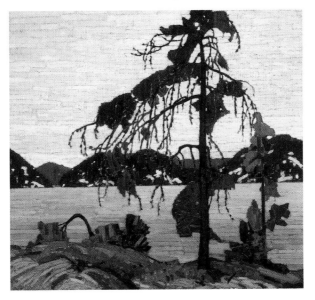

McArthur & Company

Toronto

First Canadian edition, McArthur & Company, 1999.

Canadian Cataloguing in Publication Data
Murray, Joan
 Tom Thomson: trees
ISBN 1-55278-092-9
1. Thomson, Tom, 1877–1917. I. Thomson, Tom, 1877–1917. II. Title.
ND249.T5M885 1999 759.11 C99-931752-0

Front cover photograph: Autumn Foliage, Edmonton Art Gallery
Back cover photograph: Pine Trees at Sunset, Private collection
Title page photograph: The Jack Pine, National Gallery of Canada

Cover and interior design and typesetting: Counterpunch / Linda Gustafson
Printed and bound in Canada by Freisens

McArthur & Company
322 King Street West, Suite # 402
Toronto, Ontario, Canada, M5V 1J2

10 9 8 7 6 5 4 3 2 1

One day while we were together on my island [Freure was camping on Georgian Bay and invited Thomson to camp on the island with him], I was talking to Tom about my plans for cleaning up the dead wood and trees and I said I was going to cut down all the dead trees but he said, "No, don't do that, they are beautiful."

Ernest Freure to Blodwen Davies, November 19, 1935
Blodwen Davies Papers, CMG 30 D4 *Volume 1*
National Archives of Canada, Ottawa

CONTENTS

"The Painted Things" 1

Chronology 18

The Trees 25

List of Plates 26

Further Reading 125

Illustration Credits 126

Acknowledgements 127

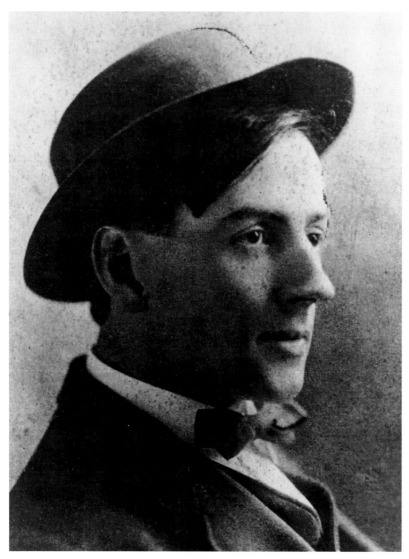

Thomson's thoughtful expression shows the romantic side to his personality.
"I love poetry best," he told an aunt about his reading habits.

Tom Thomson, c. 1905
Photograph courtesy of the National Gallery of Canada, Ottawa

"The Painted Things"

In the course of six years, between 1911 and 1917, Tom Thomson painted more than two hundred canvases and oil sketches of trees. Tree studies account for a large part of his work. They reflect the way he felt about the places he visited because wherever he went, he sought out trees to paint.

The subject is an old one in the history of art. It is found in T'ang Dynasty China (618–907), in the frescoes on lime plaster by Roman artists of the Augustan age which included sacred groves and woods, and in the scenes of Adam and Eve of the medieval world (most of which are staged with a tree). Landscape painting as it emerged in the late sixteenth and early seventeenth centuries in Europe involved a keen appreciation of nature in which trees played a part. But it was only at the beginning of the nineteenth century that landscape emerged as an important interest for North American and European artists. Its rise is related to developments in natural science and technology, especially to the growth of the railroad system and the discovery of the portable lead paint tube in the 1840s.

Nineteenth-century landscapes depict vital aspects of contemporary life. Their subjects range from the disappearance of undeveloped land because of increasing urbanization to the growth of industry at the expense of agriculture – issues that remain timely. The work of certain artists in particular, such as John Constable in his meticulous tree studies, suggests the introduction of science into the combination of factors that created their art. In Canada, artists of the nineteenth century like Cornelius Krieghoff, painted the autumn splendour of the French-Canadian countryside, and Lucius O'Brien painted watercolours of the lush British Columbian forests. Though very different painters, their

work looks similar in one respect – both celebrated the beauty of nature in Canada.

Thomson's tree paintings pay homage to this remarkably coherent attitude in earlier Canadian art, though he also painted the man-made structures designed for landscape control, such as dams. His attitude toward nature included the impact of humanity on nature, but mostly he preferred to look at landscape in its isolated glory, which he found in a section of northern Ontario – Algonquin Park. His family, and he himself, were great readers of poetry, especially that of the nineteenth-century poet Lord Byron, whose *Childe Harold's Pilgrimage* had appeared in four cantos between 1814 and 1818. In *Childe Harold's Pilgrimage*, the hero journeys through the countries of Europe, meditating on life and civilization, nature and history. His quest is heroic and dramatic: a true pilgrimage. In 1824 when Byron met his death in Greece fighting in the cause of Greek independence, he and his poetry joined the long list of heroes and martyrs to Liberty that travellers – and families like the Thomsons in far distant Canada – mentally carried with them.

A second source for Thomson was the writer and critic John Ruskin, whose varied interests encompassed everything from the visual arts to botany and geology. Ruskin's copious writings and polemics on art and social issues were extremely influential. The key to successful art-making, as Ruskin saw it, was careful observation of nature. Direct expression was to be the artist's master. Ruskin's most famous expression of this idea occurred in his handbook for young artists, *The Elements of Drawing* (1857), which it is likely Thomson read when learning to draw. In his criticism, Ruskin went beyond discussing the need for careful transcription of reality to embracing a broader meaning for successful art as the revelation of man's relation to nature and to God.

Such sources – and note how both of them are literary – would have encouraged Thomson in his wish to be acutely observant of the world

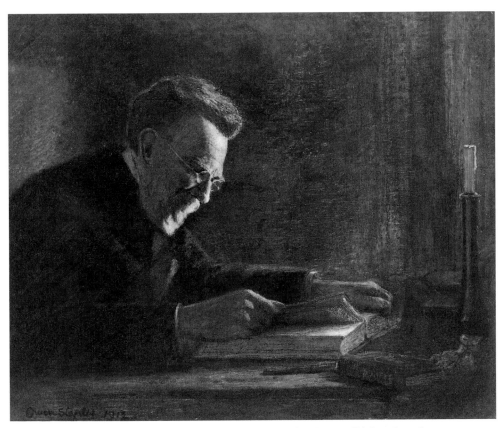

This posthumous portrait of Thomson's cousin, Dr. Brodie, shows Brodie's intensity and – a Thomson family trait – his love of reading. Brodie was one of Thomson's sources of inspiration in his way of regarding nature.

Owen Staples (1866–1949)
Portrait of William Brodie, 1912
Oil on canvas, 76.2 x 91.4 cm (30 x 36 in.)
University of Toronto Art Collection, Faculty of Dentistry

———

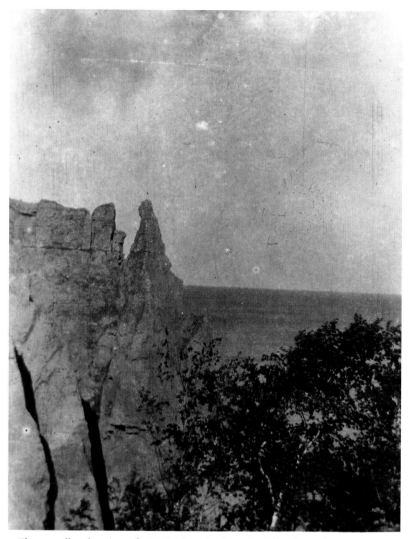

Thomson collected specimens for Dr. Brodie at Scarborough Bluffs, Thomson's sister Margaret recalled. This photograph, as well as the photo on page 6 by Thomson shows the place. That he recorded it suggests the importance of the scientific view to Thomson: Scarborough Bluffs is a fascinating natural phenomenon.

Tom Thomson
Photograph of Scarborough Bluffs, Toronto, c. 1912
Photograph courtesy of the Tom Thomson Memorial Art Gallery, Owen Sound

around him, to take in and record what all travellers wish to see and feel – to be, in fact, the ideal tourist. They would have suggested to him that he, too, could search for places where he could penetrate into the inner meaning of nature and identify passionately with external phenomena. In painting nature he would surely have felt that he was an explorer, following in the footsteps of *Childe Harold*, and even that, like Ruskin, he was a philosopher, able to understand from nature humanity's place in the vaster system.

He was justified in his sense of the highly personal vision that he could bring to nature by yet another person, a member of his own extended family, the eminent naturalist Dr. William Brodie (1831–1909). His grandmother's first cousin (though the Thomson family called him "uncle"), Brodie was known for his work as an entomologist, ornithologist, and botanist, as well as for his intense interest in vertebrate groups and molluscs. He had discovered some twenty new species of insects and many new forms of previously described species. From 1903 until his death, he held the position of provincial biologist and director of the Biological Department of the renowned Royal Ontario Museum (as it was later called) in Toronto.

Dr. Brodie was also an engaging human being, who generously encouraged young people, especially through his Saturday morning field excursions where he walked for miles, identifying different species, commenting on insects, birds, reptiles, plants, and historic sites from the scientific viewpoint. As he strode, he talked with those who accompanied him – and Thomson must have gone on these walks – about natural history, God, philosophy, and poetry, combining the eye of the scientist with that of the artist. No doubt he would have spoken to his charges of nineteenth-century American philosophers such as Henry David Thoreau, and his book *Walden, or Life in the Woods*. Like many naturalists of the nineteenth century, he saw in nature proof of divine activity

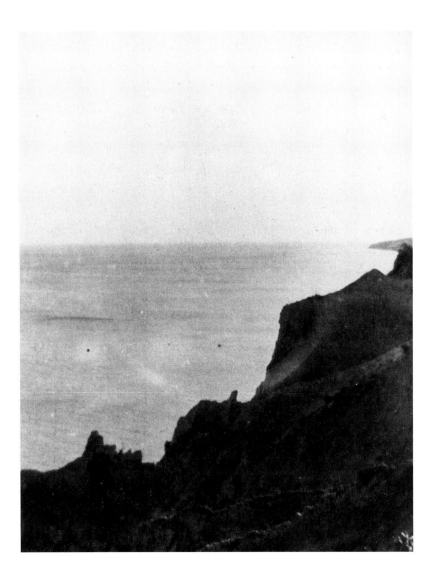

Tom Thomson
Photograph of Scarborough Bluffs, Toronto, c. 1912
Photograph courtesy of the Tom Thomson Memorial Art Gallery, Owen Sound

and considered a life lived in accord with nature a happy one. Trees would have been to him not only useful scientific documents, but also examples with aesthetic possibilities.

One of the people Brodie inspired was Thomson. "He collected specimens with Dr. Brodie," his sister Margaret said in 1971 at the sight of a photograph Thomson had taken of Scarborough Bluffs, one of the places they liked to visit – as though the mere mention of Brodie's name was enough for the listener to understand the clue. In other words, in his youth Thomson had been given the rudiments of a naturalist's training, and thereby learned how to combine keen and enthusiastic observation of nature with a sense of reverence for its mystery. We know that he wished to pursue a naturalist's career but he hadn't the financial means. It was a lack that galled him. Later, as a mature man and a painter, he was able to return to the naturalist's life he so loved through his art. Now, however, he could add to it qualities he had developed through a training in art, quickened by the years he had worked in commercial art firms – a love of colour, and a perceptive grasp of design.

The subject of trees was part of Thomson's repertoire from his earliest days as an artist. The single tree is a commonplace of Art Nouveau design, the style current to the art scene at the time of Thomson's introduction to art. The stimulus for Thomson's tree subjects may lie with one of his mentors in commercial art, J.E.H. MacDonald, the head of the design department (Thomson's section) of Grip Limited in Toronto, the firm in which Thomson worked from 1907 to 1913. MacDonald, who had been influenced by Constable's work which he had seen in England while working there from 1903 to 1906, had been painting landscapes with prominent trees in Toronto's High Park. Like MacDonald's paintings, Thomson's studies of trees give the feeling of movement that is so constant a feature of the northern landscape. Though the catalyst may have been elsewhere, Thomson pursued his subject in a manner common to

him, with great enthusiasm. He became a collector of the amazing shapes of trees: the way the trunk rises from the ground in an explosion of form, sweeping up to the release of the branches. In painting them, he explored other matters, of course – the changing of the seasons and the physical forces that influence trees, from the prevailing winds and the waters that may lie near them to the dynamics of their placement in the terrain. He had favourite motifs – he preferred a dynamic shape on the crest of a hill by a body of water. He improvised on the idea often in early sketches, both in watercolour and pen. In time, trees also expressed his way of researching a new and extraordinary place to paint – Algonquin Park.

Thomson's selection of Algonquin Park in northern Ontario as a painting site, like his interest in nature, rested on strong family roots. From Brodie and his family he would have heard how the Natural History Society, through the Royal Canadian Institute (with which it amalgamated in 1885 to become its energetic biological section), had in 1886 planned for the formation of a national park as a forest and game preserve. From 1887 to 1888, and in 1891 and 1892, his cousin Brodie was a member of that very council. In 1890, when the government appointed a Royal Commission on Game and Fish (which submitted recommendations on the formation of a provincial game park to serve as a wildlife sanctuary), Brodie followed attentively the actions of the federal government with regard to the national park. Brodie's advice, and that of his group, we know was acted upon: one week after the game and fish report was tabled in 1892, the government appointed another Royal Commission to prepare for establishing Algonquin Park. Throughout the period that the Park was coming into existence – the act to establish it was passed in 1893 – the Royal Canadian Institute, Brodie's group, continued to remind the government of the need for the Park's existence. After the Park's creation, along with other delighted naturalists, Brodie systematically explored its natural habitat, particularly its insect life. For Brodie and

When Thomson drew or painted trees, he sought a dynamic shape. He probably drew this pen sketch close in time to the watercolour of a tree, Tree *(page 28).*

Tom Thomson
On the Don River, 1908
Pen on paper, 27.9 x 46.4 cm (11 x 18¼ in.)
Private Collection, Toronto

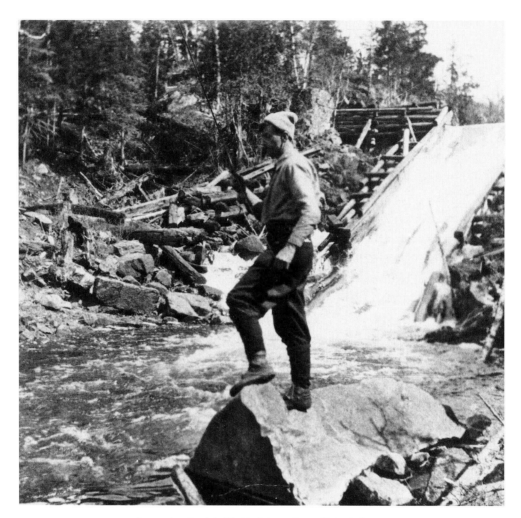

Thomson loved to fish, like his father and grandfather before him.
The National Gallery of Canada dates this photograph around 1913/14, but since it is taken
by Lawren Harris, who was only in the Park around 1915 and 1916, I have dated it later.

Lawren Harris (1885–1970)
Tom Thomson at Tea Lake Dam, Algonquin Park, c. 1915
Photograph
Photograph courtesy of the National Gallery of Canada, Ottawa

naturalists like him, such a wilderness revealed the fingerprint of God, one that had survived intact. To put it simply, Algonquin Park was the naturalist's heaven, as it is, even today.

One of the reasons for this lies in the Park's placement in the transition zone between the northern Boreal Forest and the southern Great Lakes Deciduous Forest. The area reflects an ever-changing balance between different forest types from the hardwoods on the upland slopes to hemlocks on the north slopes, to spruce and tamarack in low-lying lakeshore areas. The black spruce were the earliest in the evolutionary record; the hardwoods the latest. Brodie and his friends would have been fascinated by the flowering plants and wild life, as transitional as the trees. Here, typical northern plants and northern birds such as the spruce grouse, combine with species more typical of deciduous forests, such as the ruffed grouse. Brodie was planning to make a visit to the Park in 1906, three years before his death, as we know from his correspondence.

When Thomson went north, family ties and pride would have given him a special feeling about the Park. Deep in his being, he would have been moved by the nearly eight thousand square kilometres of forest, lake, and river that his cousin Brodie had managed – or so it might have seemed – to be set aside as a conservation area. The Park was and is what we take to be wilderness, and its being set apart guaranteed that this region would be accessible to the public in perpetuity. It is information about this defined space that Thomson wished to convey to an audience eager for such knowledge – because the Park was a topical matter in the news of the day.

There was one more reason for painting in Algonquin Park – a matter as close to his heart as his relation to his cousin – fishing. This pastime also had family roots for Thomson. He was a keen fisherman, like his father and grandfather before him. The waters of Algonquin Park were famous for the size and sweetness of their brook trout. Thomson loved to

fish for them. Photographs taken in the Park show Thomson fishing, standing with his catch or fixing bait, or seated on the porch of Mowat Lodge with friends holding their catch between them.

"Where he fished, he painted," a brother recalled. So, in the Park to fish, he settled down to sketch. And the scenery was worth it: it was rugged, different, all fallen trees floating on the water – as we see in his own photograph and one of his early sketches. That the trees he painted did not always correspond to reality he recognized. "A photo would be great but the painted things are awful," he wrote. Yet his tree subjects are expressive of his dynamic, energetic personality as well as of his poetic frame of mind. Back in the studio, he would translate his sketches into canvases that were shaped by his recollection of poetry he knew so well. In *The West Wind*, for instance, he painted the cant of a tree as it leans into the embrace of another, bending like a bow to form the frame of a harp or a lyre, an apt paraphrase of Percy Bysshe Shelley's *Ode to the West Wind*, where the poet had begged the wind to make of him, "its lyre, even as the forest is."

From earliest times, forests have been places of mythical transformation, where trees and people can exchange places. The sites of Thomson's trees often seem to be fabricated, and his trees, anthropomorphic. In his heart, he accepted the tradition of the forest as a place of refuge for people like himself, individuals who, because they were artists, were marginal members of society. Besides the idea of the forest as refuge, he would have thought of another idea, drawn from age-old spiritual beliefs, that people who seek vision must go alone into the wilderness and live there for a time. If they are chosen, they will return with a message, a vision, or a marvellous occurrence which, if not a prophecy, will at least be worth discussion and meditation.

John Ruskin had taken an allegorical view of nature, seeing the vine as a symbol of waywardness, and the pine, its complement, as an emblem

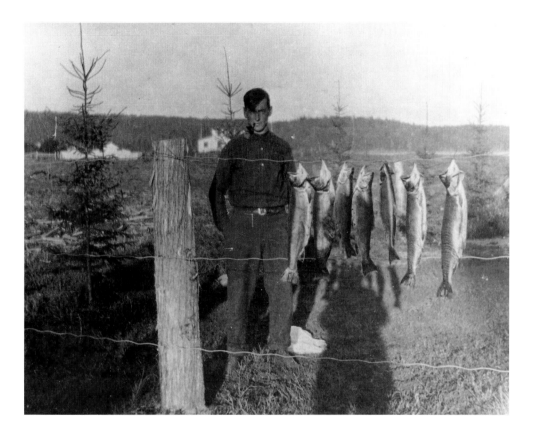

Lawren Harris (1885–1970)
Photograph of Tom Thomson with his catch at Canoe Lake, Algonquin Park, c. 1915
Photograph
Photograph courtesy of the National Archives of Canada, Ottawa (NA 125406)
Gift of G. Blair Laing, Toronto

Thomson particularly noted the trees in Algonquin Park as we can see from one of his own photographs and an early sketch.

Tom Thomson
Photograph of Algonquin Park, c. 1912
Photograph courtesy of the Tom Thomson Memorial Art Gallery, Owen Sound

of steadfastness since it refuses to bend with the wind. In the winter of 1916 to 1917, Thomson painted a woodland vine in the depths of the forest, as well as several paintings, almost portraits, of pines. Perhaps the subject signified to him, as it had to Ruskin, opposite ends of the human spectrum – those who lean upon others and those who stand forthright and unafraid. He may have been privately questioning himself, and wondering whether he had the grit to stick to the artist's life.

He played out all of these ideas on the stage he had selected to represent himself – the forest floor. It was a setting for a sort of morality play, as he must have realized, with its universal cycle of death and rebirth, spring flowering into summer, fall, and winter in a series of repetitive subjects. "The breath of the Four Seasons must ever be our basic inspiration," he would have said along with MacDonald.

The trees Thomson painted when he first came to the Park suggest that he was painstakingly serious in trying to convey the scene before him. His oil sketches are, like his photographs, literal renderings of some of the salient characteristics of the Algonquin Park he saw before him. His essential concern was to record a particular environment, to revel in the harsher elements of the landscape, to capture aspects of nature not immediately beautiful. Yet these are not documentary images. They have a poetic resonance – such is the attention to the terms of reference. As time progressed, he sought to make his subjects more expressive, observing the specific characteristics of the species of tree he was painting, as well as their individual characteristics. He collected different varieties, travelling through the Park to discover the Jack pine that grows in the northeast section along the Ottawa River.

In his approach to landscape he reflected a highly specific vocabulary based not only on literature but also on painting, and he did so in relation to specific social codes and assumptions. His works, like his photographs, feed from the vocabulary of tourism, and structure themselves according

to the ideas of a class of people who looked upon landscape scenery in aesthetic and philosophic terms; he was part of a picturesque tradition that viewed places such as Algonquin Park as a wilderness alternative to urban life. Thomson recorded selected spots, imposing on them a highly edited version of the Park — exclusive and bound by mythology, rather than by the social reality he encountered. In such landscapes, nature is the key. The land, except in a few of his sketches, is empty of human presence. Cultural symbolism suggested that places such as the Park should be wild, and Thomson painted them sublime in scale, with a wonderfully realized setting of light, rock, sky, space, and trees, but bereft of evidence of settlement. His configurations, particularly his trees, offer points of definition. They provide a sense of scale and measurement, a way of placing an historic code upon the land. He made such trees into something remarkable in terms of visual spectacle. The play of pattern, of texture, and of light expresses an almost metaphysical presence. These are primary points of contemplation as if they, literally, stand in for the landscape.

Painting trees was an unconscious form of therapy for Thomson. As a boy, he had wanted to partake of the naturalist's life but he had been thwarted in his desire to acquire the necessary training. Now, as a painter, he took to the business with abandon, creating what he called "records" for all the world to see that he was, after all, recording a truth — not only nature's but that of his own life. He was hard at work, with — we may think — the unacknowledged ghosts of several poets, Ruskin, and his cousin Brodie whispering in his ear. The result in his work was more poetic than scientific. The key to his work is the quality of something irrational, not a matter of measurement. Particularly, his trees are ecstatic living presences, like elemental spirits. He had become the nature he sought, not just an observer but part of the living environment, adapting to the different seasons, establishing a dialogue with the place, and understanding its network of interrelated processes.

Wherever he went, he sought out trees to paint.

Tom Thomson
Northern Lake, c. 1913
Oil on canvas board, 25.1 x 17.8 cm (9 $\frac{7}{8}$ x 7 in.)
Private Collection, Montreal

CHRONOLOGY

1877

August 5. Tom Thomson born in the town of Claremont in Pickering Township, Ontario. He is the sixth of ten children of John Thomson (1840–1930) and Margaret J. Matheson (1842–1925).

Autumn. The Thomson family moves to Leith, near Owen Sound.

1887?

Attends Leith School.

1898

Joins Kennedy's Foundry, Owen Sound, as a machinist apprentice but quits after eight months.

Goes west to join the harvesters' excursion.

Autumn. Moves to Chatham, Ontario, and attends the Canada Business College till 1901 to prepare himself for office work.

1901

Summer (?). Goes west. Moves to Seattle. Works at Diller Hotel as lift boy.

Autumn (?). Attends Acme Business College.

1902

Joins Maring and Ladd (in 1903 changes name to Maring and Blake), Seattle.

1903
Works at Maring and Blake, Seattle.

1904
Works at Seattle Engraving Co.

1905
Meets and falls in love with Alice Elinor Lambert. Proposes marriage but
 because of a gaffe on the part of Lambert or through mistaken gal-
 lantry, leaves Seattle.
Returns to Owen Sound.
Settles in Toronto. Decides to become an artist.
June. Joins the Art Department of Legge Brothers (a commercial art
 firm) as senior artist.

1906
Cultivates his ambition to be an artist by attending Central Ontario
 School of Art and Design at night; studies Life Drawing and the
 Antique (instructor William Cruikshank). Draws with zeal and paints
 his first painting, as well as copying work by others. Probably at this
 time begins to collects specimens for his cousin Dr. William Brodie
 (1831–1909), one of the foremost naturalists of his day and from 1903
 to 1909 director of the Biological Department of the Provincial
 Museum in Toronto (later the Royal Ontario Museum).

1907 or 1908
Joins Grip Limited, a leading commercial art firm, in the design section
 under J.E.H. MacDonald.

1908

Becomes friends with Elizabeth McCarnen (she leaves Toronto in 1910).

1911

Works at Lake Scugog with H.B. Jackson (Ben).

November. MacDonald exhibits Thomson's sketches at the Arts & Letters Club. Through Lawren Harris meets Dr. MacCallum, an ophthalmologist and in time, his patron.

1911

Late Autumn 1911 or Early Spring 1912. Acquires first real sketch box and begins to regard painting seriously.

1912

May. Travels to Algonquin Park with H.B. Jackson. Camps at Tea Lake Dam and Canoe Lake. Meets forest ranger Mark Robinson.

Summer. Travels to the Mississagi Forest Reserve, west of Sudbury, with friend and fellow artist W. Smithson Broadhead. Continues to paint. Meets Grey Owl, as he is known later, who visits him in Toronto the following winter. Returns to Toronto.

October. Employed by Rous and Mann Press Limited as an artist at seventy-five cents per hour (workweek is forty-six-and-a-half hours). Stays until May 1913.

Meets Dr. MacCallum at MacDonald's studio.

1913

April 5–26. Exhibits *[A] Northern Lake* in Forty-First Ontario Society of Artists Exhibition (selected for Education Department of Ontario Government and purchased for $250).

May. Encouraged by Dr. MacCallum and other friends, Thomson decides to leave commercial art and paint full-time.

Travels to Algonquin Park to paint and work as a guide (stays till autumn; establishes a lasting pattern of going to Algonquin Park in the spring and staying till the autumn, returning to Toronto to paint during the winter months).

November. Returns to Toronto. Dr. MacCallum brings him to meet A.Y. Jackson and see his painting *Terre Sauvage*. Thomson is fascinated and returns to watch its development with keen interest, becoming a good friend of Jackson's in the process.

1914

January 19. The new Studio Building on Severn Street opens its doors: Thomson shares Studio One with A.Y. Jackson who stays till the autumn.

February 7–28. Exhibits in Art Gallery of Toronto's Exhibiiton of *Little Pictures by Canadian Artists* (Second Annual).

March 14–April 11. Exhibits in Forty-Second Ontario Society of Artists Exhibition, Toronto.

April. A.Y. Jackson shows Thomson examples of Impressionism and Pointillism; Thomson is impressed.

Mid-May. With Arthur Lismer, returns to Algonquin Park.

July. Georgian Bay. Returns to Algonquin Park, then goes to Toronto. World War I breaks out.

Mid-September. Thomson and Jackson arrive in Algonquin Park.

October 3. Lismer arrives in the Park.

October 18–23. Week of Jackson's departure from the Park. Returns to Toronto.

November. Exhibits in Thirty-Sixth Royal Canadian Academy of Arts Exhibition, Toronto.

November 18. Thomson leaves the Park. Returns to Toronto.

December. Thomson is joined in Studio One of the Studio Building by Franklin Carmichael.

December 13 (opening). Thomson exhibits in *Pictures and Sculptures Given by Canadian Artists in Aid of the Patriotic Fund*, Royal Canadian Academy of Arts, Toronto.

1915

March 13–April 10 . Exhibits in Forty-Third Ontario Society of Artists Exhibition, Toronto.

April 22. Stays at Owen Sound for a week and paints a few sketches.

Returns to Algonquin Park. Focuses on painting skies. Works as a fire ranger, travelling a great deal in the Park.

July. Buys a new Chestnut canoe, silk tent, etc., and starts out from Canoe Lake on a long trip coming out at South River around Labour Day.

A.Y. Jackson enlists in the 60th Infantry Battalion.

August 28–September 13. Exhibits in Canadian National Exhibition, Toronto.

September 8–16. Exhibits in the Fine Arts Gallery of the Nova Scotia Provincial Exhibition, Halifax.

Plans to go up South River and cross into Tea Lake.

November. At Round Lake.

Returns to Toronto and to The Shack attached to the Studio Building, Toronto.

December 6. Show of *Oil Sketches*, Arts & Letters Club, Toronto.

1916

Spring. Returns to Algonquin Park.

March 11–April 15. Exhibits in Forty-Fourth Ontario Society of Artists Exhibition, Toronto.

April 28. Lawren Harris, Harris's cousin Chester, and Dr. MacCallum visit Thomson in Algonquin Park.

May. Works as a fire ranger.

June. Lawren Harris is posted to the 10th Regiment of Royal Grenadiers.

August. Travels to Petawawa Gorges.

August 26–September 11. Exhibits in Canadian National Exhibition, Toronto.

Autumn. Travels near Grand Lake.

November 16–December 16. Exhibits in Thirty-Eighth Royal Canadian Academy of Arts Exhibition, Toronto.

1917

End of March through first half of April. Arrives in Algonquin Park.

April 28. Buys Guide's Licence.

May 24. Dr. MacCallum and son Arthur arrive for fishing trip.

July 8(?). Death due to drowning. Bruise on right temple four inches long.

July 16. Body found in Canoe Lake by his friend and fellow guide George Rowe.

THE TREES

Since 1970, I have been working on a complete catalogue of Thomson's work. I have visited public and private collections, closely examined the paintings themselves, and interviewed the Thomson family and his friends. As well, I have studied correspondence and newspaper and magazine articles in an effort to develop a chronological inventory of his work and a comprehensive vision of the man himself.

For this celebration of Thomson's tree subjects, I have selected works that I consider to be his best, both from the point of view of technical ability and emotional impact. They represent different stages of his development as well as the varieties of trees in his work. Setting them in chronological order indicates his development – his growing certainty in handling paint, his feeling for colour, and his bold way of composing, one in which design played an important part.

His small sketches, mostly 21.6 x 26.7 cm (8½ x 10½ in.) in size, give us the best indication of his aims as an artist. Their materials provide internal evidence for dating his work. During his career as a painter, Thomson used different materials. In 1914, his wood panels developed vertical cracks. In the spring and autumn of 1915, he used terracotta-coloured and flesh-coloured paint as sealers; the following year, he used ochre paint. In the spring of 1917, as in *An Ice Covered Lake*, he cut up old crates to make 12.7 x 17.8 cm (5 x 7 in.) panels; the letters "IT CO/ORNIA," which presumably spelled out what was in the crate (possibly coming from California) are on the reverse of the sketch.

LIST OF PLATES

(Where a title is duplicated, the collection is given)

Algonquin, Autumn 91

Algonquin Park 77

Autumn, Algonquin Park (Private Collection, Toronto) 61

Autumn, Algonquin Park (Private Collection, Toronto) 103

Autumn, Algonquin Park (Private Collection, Calgary) 105

Autumn Birches (Art Gallery of Ontario) 63

Autumn Birches (McMichael Canadian Art Collection) 97

Autumn Foliage (Art Gallery of Ontario) 55

Autumn Foliage (Edmonton Art Gallery) 101

Autumn Foliage (National Gallery of Canada) 107

Autumn Landscape 41

Beech Grove 95

The Birch Grove, Autumn 111

Birches 117

Black Spruce in Autumn 67

Black Spruce and Maple 57

Dead Spruce 65

Early Winter Growth 109

First Snow, Canoe Lake 69

Forest, October 93

An Ice Covered Lake 119

The Jack Pine 113

Moonlight and Birches 49

Nocturne 87

Northern River 47

Pine Island 81

Pine Island, Georgian Bay 45

Pine Trees at Sunset 51

The Pool 71

Purple Hill 75

Ragged Lake 53

Ragged Oaks 89

Ragged Pine (McMichael Canadian Art Collection) 83

Ragged Pine (Private Collection, Toronto) 85

Red Leaves 39

Red Rocks, Georgian Bay 33

Red Sumac 99

Snow and Earth 121

Snow Shadows 73

Soft Maple in Autumn 35

Spring, Algonquin 31

Spring Breakup 123

Tamaracks 59

Tree 29

Twisted Maple (The Red Tree) 37

The West Wind (Sketch) 79

The West Wind 115

Wood Interior, Autumn, Algonquin Park 43

TREE, C. 1908

Thomson's background in commercial design gave him decided advantages when he became an artist: one was the idea of reusing a motif, drawn from visual experience or memory, in different works, thus giving access to an array of fresh starts. He used this image of a tree in a pen sketch (page 9), as well as developing the idea of the tree itself, as we can see from the series in this book. He believed that the artist should be able to try a number of approaches to find new combinations.

What strikes us first about *Tree* is the strong diagonal of the tree trunk. For greater clarity, part of it is outlined against the sky.

Watercolour on paper, 19.1 x 12.7 cm (7 ½ x 5 in.)
Private Collection, Toronto

SPRING, ALGONQUIN, C. 1914

Thomson learned about nature from his cousin, Dr. William Brodie, the foremost naturalist of his day. As a young man Thomson collected specimens for his cousin and others.

The eye of a naturalist is central to Thomson's painting. It accounts for the way he saw the land — so accurately, almost as though it were a contour map laid before him. From travelling about Algonquin Park, he knew what was behind and beyond what he painted. He conveyed this knowledge in the small sketches he liked to call his "boards," because they were painted on pieces of wood.

He was always interested in the forms and designs provided by nature. In this sketch, he captures the energetic movement of trees on the shore of a lake. It must have been a windy day.

Oil on panel, 21.6 x 27.0 cm (8 1/2 x 10 5/8 in.)
Private Collection, Toronto

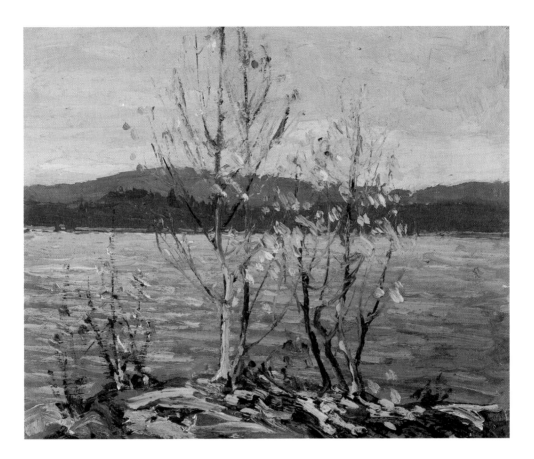

Red Rocks, Georgian Bay, 1914

Besides Algonquin Park, Thomson also travelled to Georgian Bay, where he found interest in the shapes of trees springing from the rocks. He may have painted this scene from a canoe.

Oil on board, 21.6 x 26.7 cm (8 ½ x 10 ½ in.)
Private Collection, Calgary

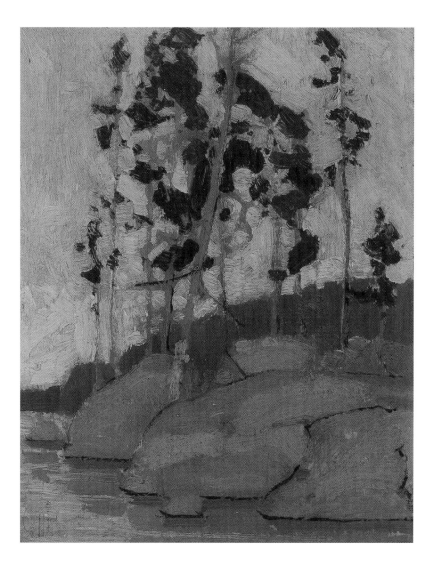

Soft Maple in Autumn, c. 1914

In the autumn of 1914, Thomson had invited F.H. Varley, with his wife, A.Y. Jackson, and Arthur Lismer, and Lismer's wife and child, to camp with him in Algonquin Park. He knew Jackson, Lismer, and Varley would help him discover new motifs.

"The country is a revelation to me, and completely bowled me over at first," Varley wrote Dr. J.M. MacCallum (1860–1943), the Toronto ophthalmologist who was their friend and patron, about the park. Though the weather was warm and sultry, the maples were already almost finished, their bright leaves having fallen. The birches, though, were still rich in colour. When Lismer arrived, he called the colour "glorious" in another letter to MacCallum. The warm weather was followed by heavy rain and windy skies.

Together, they were inspired. Thomson, like his friends, began to apply brighter colour to his panels, and to use it in a special way – placing it over the surface in little touches so the result was higher in key.

Already Jackson seems to have been thinking of the group as the foundation of a new school and of Thomson as a key figure. He wrote MacCallum that "Tom seems quite enthusiastic and I expect is quite an inspiring man to work with. You need a man with you who tries to do the impossible. To do what you know is easily within your powers never has given rise to a great school of art or anything else."

Thomson would have painted this sketch, since the tree is maple, soon after he arrived in the park. Notice the way the trees extend diagonally across the surface of the panel. Thomson loved the drive and energy a diagonal gave his work. It reflected his own vitality and excitement.

The maple is Canada's national tree. It has strikingly brilliant foliage in the autumn.

Oil on wood panel, 25.4 x 17.5 cm (10 x 6⅞ in.)
Tom Thomson Memorial Art Gallery, Owen Sound
Gift of Mrs. J.G. Henry, 1967

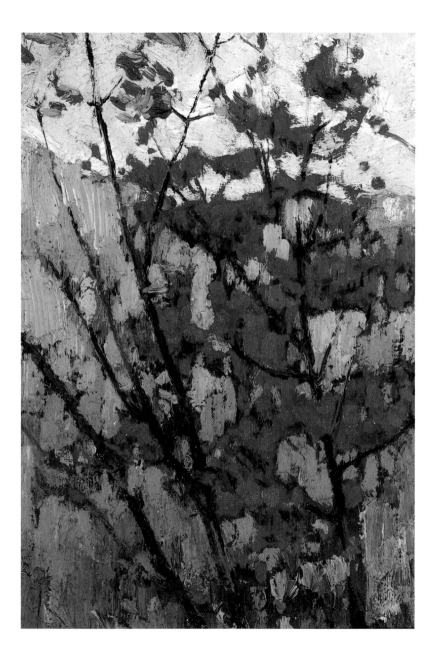

Twisted Maple (The Red Tree), c. 1914

Like the trees in *Soft Maple in Autumn*, the tree extends diagonally across the surface of the panel. In this sketch, it practically projects into the viewer's space.

Oil on panel, 26.7 x 20.9 cm (10$\frac{1}{2}$ x 8$\frac{3}{16}$ in.)

McMichael Canadian Art Collection, Kleinburg

Gift of Mrs. Margaret Thomson Tweedale

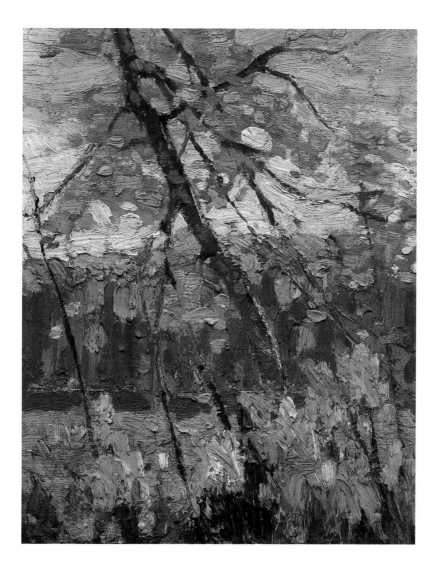

Red Leaves, c. 1914

Red Leaves has a decided simplification of form, and bold surface pattern. Jackson said that, in his work of this season, Thomson was transposing, eliminating, designing, experimenting, finding "happy colour motifs amid tangle and confusion, revelling in paint." The key word is transposing, that is, creating a synthesis of design. The idea that he could, like God, transform nature – so different from simply copying what was before him – helped his personal vision come into play, and stimulated his ideas of design, light and dark pattern, coherent pictorial structure, and rhythmic continuity.

The tree, a maple, with brilliant leaves, may indicate that the sketch is later than *Soft Maple in Autumn*. Thomson must have painted it when he first came to the park. The maples were almost "all stripped of leaves," he wrote Dr. MacCallum on October 6, 1914.

Oil on wood, 21.2 x 26.7 cm (8 ⁵/₁₆ x 10 ¹/₂ in.)
National Gallery of Canada, Ottawa
Bequest of Dr. J.M. MacCallum, Toronto, 1944

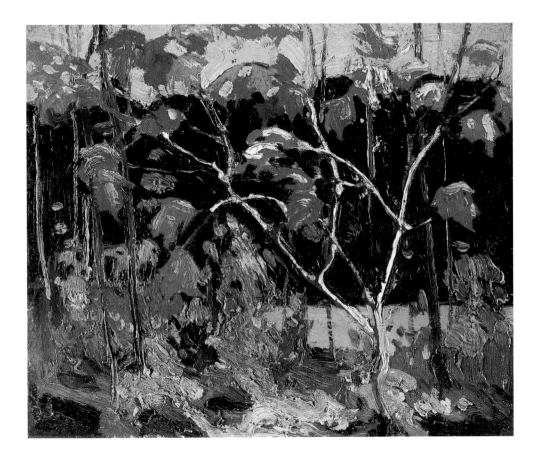

Autumn Landscape, c. 1914

In this little grove, some of the trees are birches.

Oil on panel, 26.4 x 21.6 cm (10 ³/₈ x 8 ½ in.)
Private Collection, Calgary

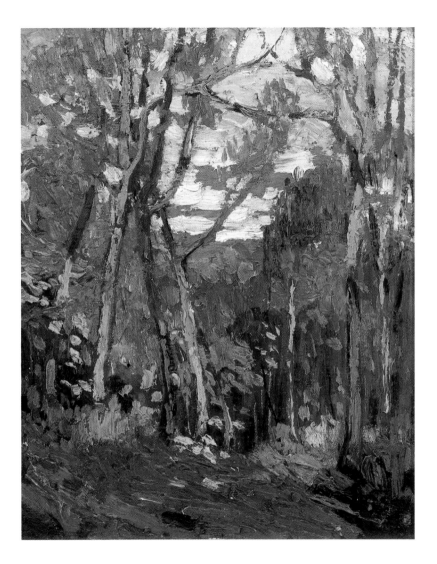

Wood Interior, Autumn, Algonquin Park, c. 1914

This sketch is probably one of the ones Thomson painted in the fall of
1914 under the inspiration of the group: note the way he has chosen to
paint birches (they were the trees still rich in colour after the maple leaves
had fallen).

Oil on panel, 26.4 x 21.6 cm (10⅜ x 8½ in.)
Private Collection, Calgary

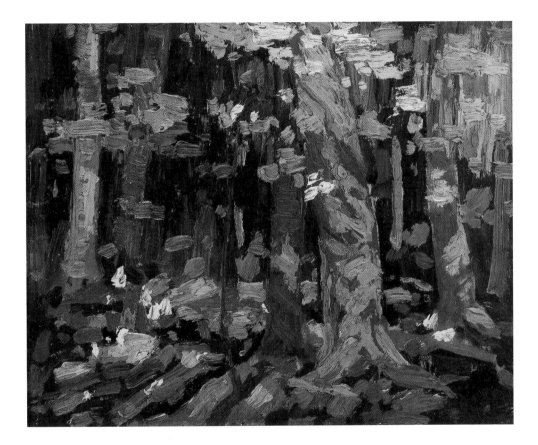

Pine Island, Georgian Bay, c. 1914–1915(?)

The way Thomson and his friends latched onto the idea of the North in their work was important to his acceptance as an artist. Labels were easy; if someone was known as a commercial artist (which is what many of them were), the public was not going to be interested. Their use of northern imagery was an act of subtle aggression, a form of self-definition that got them off the commercial hook.

That the trees are pines in this painting would have mattered to Thomson. Notice the artful way he treats the subject, purifying and strengthening the trajectory of tree trunks and branches to reflect the sweeping lines and S-curves of the fashionable international style of Art Nouveau. He added as well a Pointillist effect through the dots of colour he used in the sky.

Oil on canvas, 153.2 x 127.7 cm (60 ¼ x 50 ¼ in.)
National Gallery of Canada, Ottawa
Bequest of Dr. J.M. MacCallum, Toronto, 1944

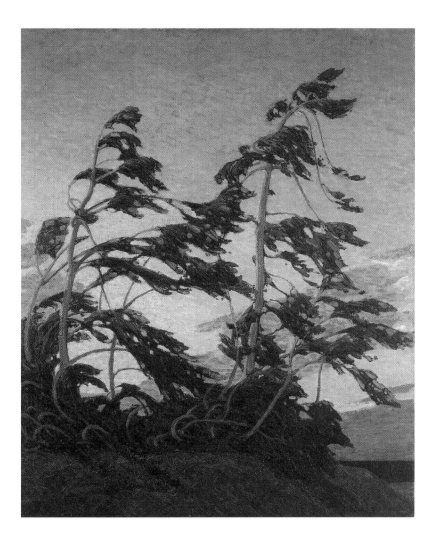

Northern River, c. 1914–1915

Among the three canvases Thomson painted during the winter of
1914–1915 was *Northern River*. Thomson himself, though usually critical
concerning his own talent, once confided to a nephew that, of all his
works, he thought the finished canvas of this painting "not half bad."
The choice of the title may have occurred to Thomson because of the
title of a poem (Thomson always loved poetry) by Canadian poet (and
resident of Owen Sound, which was near Leith where Thomson grew
up), William Wilfred Campbell (1861–1918).

This is the northern forest, "dusk and dim," of which Campbell
wrote. Thomson has conveyed a poetic, mysterious quality through the
composition of a well-lit central space seen through dark silhouetted
shafts of trees. The painting's quiet mood may well be associated, as
many have speculated, with the interior of a church.

The gouache preparatory study in the collection of the Art Gallery
of Ontario in Toronto suggests that Thomson followed his own work
closely in preparing the final canvas, though with characteristic differ-
ences. The canvas stabilizes what is fleeting and accidental in the sketch.
Inevitably, when in the studio painting a canvas, Thomson mentally took
a step backwards to deal with his subject. He added foreground space to
the conception in the sketch so that the image would be better set off in
depth. The trees, too, are better defined, simplified, with less foliage than
those of the sketch.

The place where Thomson painted the study is unknown. One of his
friends, Winifred Trainor, said it was outside Algonquin Park.

Oil on canvas, 115.1 x 102.0 cm (45 ¼ x 40 ⅛ in.)
National Gallery of Canada, Ottawa
Purchased, 1915

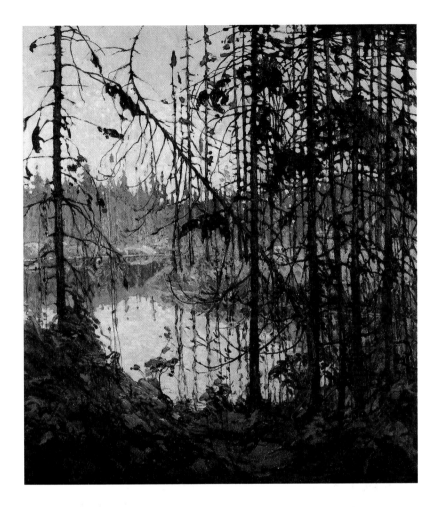

MOONLIGHT AND BIRCHES, C. 1915

The advanced art of the first decades of the century was less a concerted movement than a convergence of styles. It was manifested chiefly, but not exclusively, in landscapes executed with soft painterly application and muted colour harmonies. It had two principal tributaries: the followers of the French Barbizon School in Canada, and Aestheticism, epitomized by the works of the American expatriate artist James McNeill Whistler, and found in Canada in painters such as Archibald Browne, best known for his luminous nocturnes. Tonalists tended to emulate one style or the other or to combine features of both.

Light had been a crucial symbol in European religious art from an early time. Tonalism is distinguished by its subtle use: its subjects are framed from fugitive moments of dim light, especially moonlight. The effect was to turn the painting away from naturalism so that it became an abstract emblem of contemplation.

Thomson's art had Tonalist roots. He was always to enjoy painting night scenes, and he delighted in the unusual colours caused by moonlight.

Oil on panel, 22.0 x 26.9 cm (8 ⅝ x 10 ⁹/₁₆ in.)
McMichael Canadian Art Collection, Kleinburg
Gift of Mrs. H. P. de Pencier

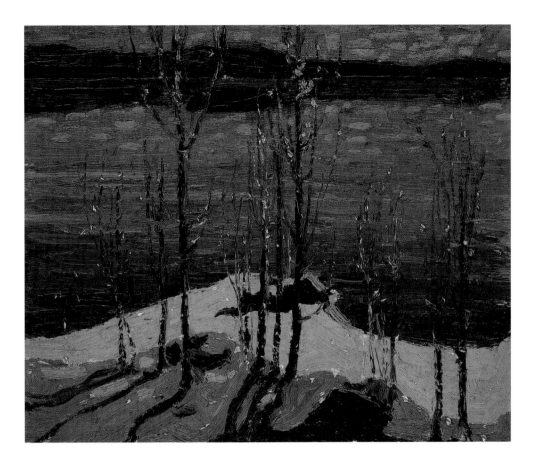

PINE TREES AT SUNSET, C. 1915

A friend recalled that Thomson used to say of nature, "Lift it up, bring it out." For the motif of this sketch, Thomson silhouetted pines against the sunset sky. It was a motif he was to use later in *The Jack Pine*.

Oil on pressed board, 26.7 x 21.0 cm (10½ x 8¼ in.)
Private Collection

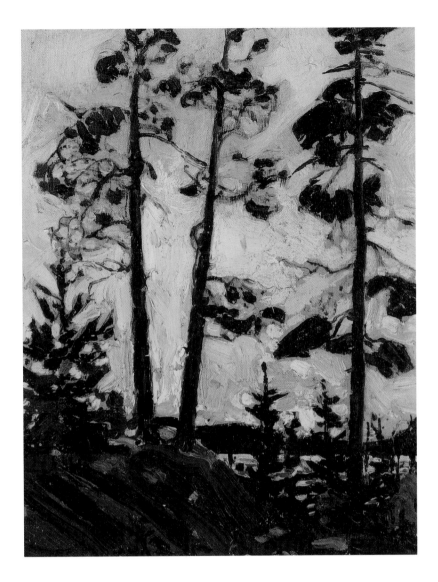

RAGGED LAKE, C. 1915

The fallen tree in the foreground adds interest to the sketch.

Oil on wood panel, 21.2 x 26.2 cm (8¾ x 10½ in.)

Art Gallery of Hamilton, Hamilton

Gift of Mrs. G.Y. Douglas, 1963

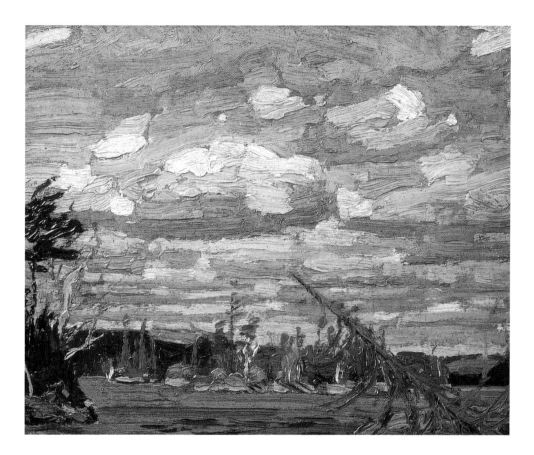

Autumn Foliage, 1915

Our immediate response to Thomson's sketches is to the natural elements: the way he has suggested the placement of trees, foliage, the colour of the sky. But then his art takes over – his brisk but delicate handling of paint, use of colour, and powerfully summarized form, all creating drama and design.

Thomson selected this hillside in Algonquin Park because of its vivid autumn colour and differently shaped trees. The flat surface design, dark contours, and intense colour give a contemporary look to the sketch.

Oil on panel, 21.6 x 26.7 cm (8 $\frac{1}{2}$ x 10 $\frac{1}{2}$ in.)
Art Gallery of Ontario, Toronto
Gift of the Reuben and Kate Leonard Canadian Fund, 1927

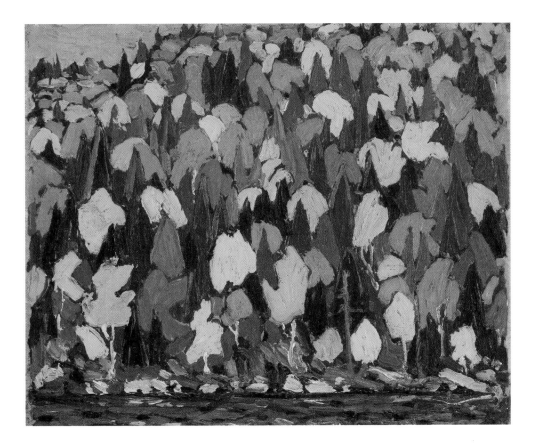

BLACK SPRUCE AND MAPLE, 1915

This sketch is one of a number of studies of spruce and tamarack
Thomson painted in Algonquin Park. However, since Lawren Harris
once owned it, we may imagine that he knew that it taught important
lessons about scale, space, abbreviation of form, and the need to distort
colour to convey light. Thomson made the colourful trees of autumn in
the north woods appear brighter by painting them against a dark back-
ground.

The combination of black spruce and maple suggests that Thomson
chose a swampy lowland in which to paint. Tamarack and yellow birch
generally grow there, too.

Oil on panel, 21.6 x 26.7 cm (8$\frac{1}{2}$ x 10$\frac{1}{2}$ in.)

Art Gallery of Ontario, Toronto

Gift of Mr. and Mrs. Lawren Harris, Toronto, 1927

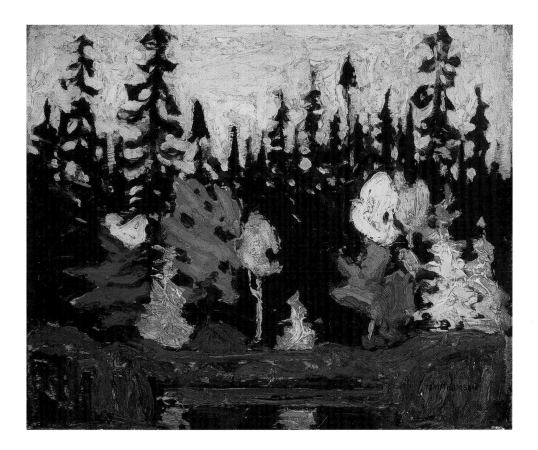

TAMARACKS, C. 1915

In this sketch, Thomson decided to record the distinctive yellow colour of tamarack needles in the late autumn.

Oil on panel, 21.3 x 26.7 cm (8 $\frac{3}{8}$ x 10 $\frac{1}{2}$ in.)
McMichael Canadian Art Collection, Kleinburg
Gift of Mr. R.A. Laidlaw

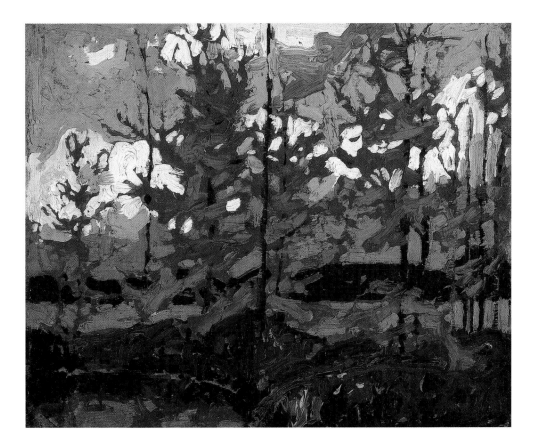

Autumn, Algonquin Park, c. 1915

Here, the colour red serves to ignite an otherwise sombre scene.

In the autumn of 1915, Thomson used a coat of terracotta paint to seal his boards before painting on them. In this sketch the terracotta colour of the undercoat is clearly visible, thus allowing us to date the work to this season.

Oil on board, 21.5 x 26.4 cm (10^1/$_2$ x 8^1/$_2$ in.)
Private Collection, Toronto

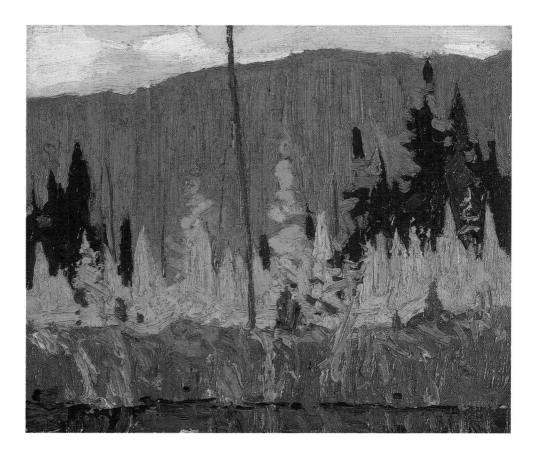

Autumn Birches, 1915

Harris may have selected this sketch for himself from the group left by Thomson in the studio shack where he worked. There is an exciting two-dimensional quality to the design.

The chalky white bark and delicate foliage of the white birch contrasts with the more sombre green of the pine.

Oil on panel, 21.0 x 26.7 cm (8 ¼ x 10 ½ in.)
Art Gallery of Ontario, Toronto
Gift of Mr. and Mrs. Lawren Harris, Toronto, 1927

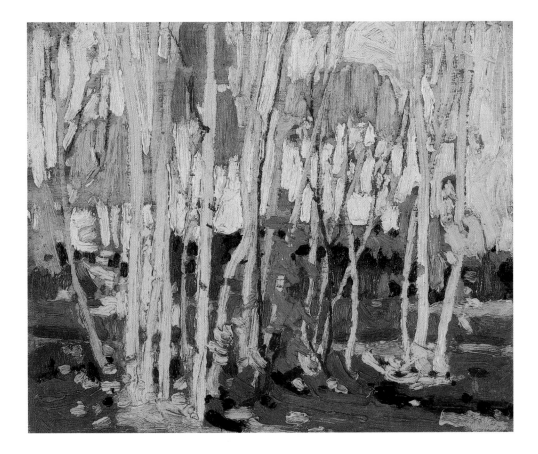

DEAD SPRUCE, C. 1915

The sombre colours relate the sketch to other works painted by Thomson in 1915.

Spruce can be recognized by its symmetrical, pyramid-shaped outline and by the branches growing at regular intervals in whorls from the straight main trunk.

Oil on wood, 21.5 x 26.2 cm (8 ⁷/₁₆ x 10 ⁵/₁₆ in.)
National Gallery of Canada, Ottawa
Purchased, 1918

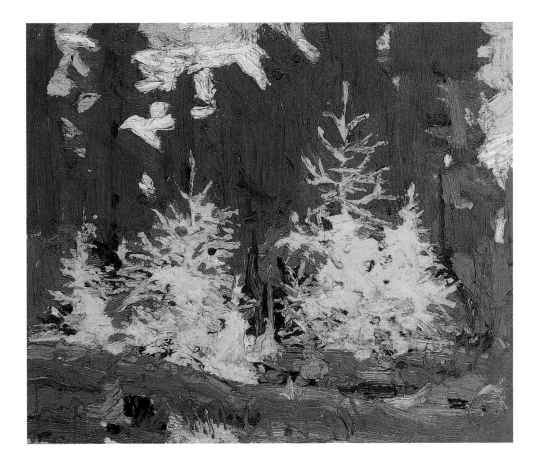

BLACK SPRUCE IN AUTUMN, C. 1915

In 1915, Thomson planned to go "back up South River, cross into Tea
Lake, and down as far as Cauchon," as he wrote his friend Dr. MacCallum
on September 9th. This sketch suggests that he made the trip he pro-
posed: the hills resemble those in his other sketches of Lake Cauchon.
As in other sketches painted this season, Thomson ignites an otherwise
dark scene with brilliant colour in one section, here, the background.

Oil on board, 21.7 x 26.8 cm (8 1/2 x 10 9/16 in.)

McMichael Canadian Art Collection, Kleinburg

Gift of Mrs. Margaret Thomson Tweedale, 1966

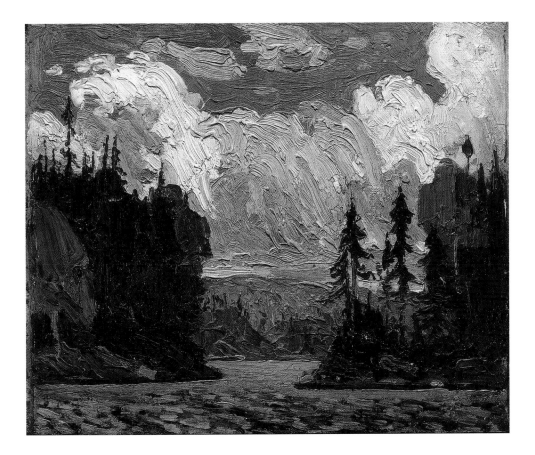

First Snow, Canoe Lake, 1915

On the verso of this sketch Dr. MacCallum, Thomson's friend, wrote "First Snow fall 1915"; hence, the date. Thomson only rarely painted the moment when the snow fell in Algonquin Park. He softened the shapes, and greyed the colours to create an evocative mood.

Oil on panel, 20.3 x 27 cm (8 x 10 ⅝ in.)
Private Collection, Montreal

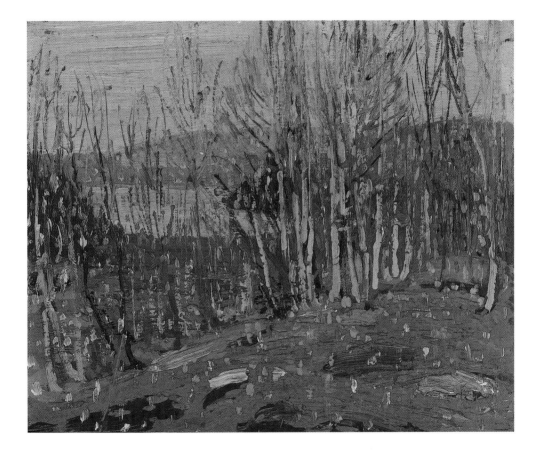

THE POOL, C. 1915

Thomson's way of dazzling an audience has less to do with colour and technique than with his ability to toy with his viewers' perceptions, usually by presenting contradictions and seeming to reconcile them at the same instant. For a time, he did this mostly by shuttling between the worlds of Tonalism and Post-Impressionism. In this painting, he illuminated a scene in nature by transforming it into a decorative pattern while at the same time making a point of an increasing bold handling; the painting is a horizontal variation of Thomson's *Northern River* subject but painted with impeccable virtuosity while suggesting that beneath the motif lies an actual place of uncommon beauty.

Thomson enjoyed revisiting his earlier notions. In a way, his work is a discourse on the breadth of a painting format that he himself created.

Oil on canvas, 76.4 x 81.7 cm (30 x 32 ¼ in.)
National Gallery of Canada, Ottawa
Bequest of Dr. J.M. MacCallum, Toronto, 1944

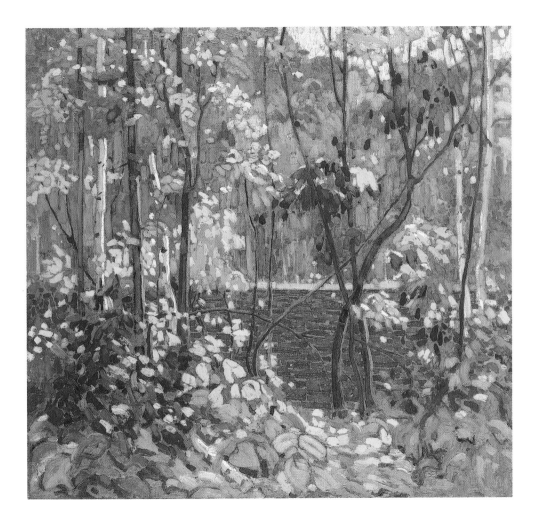

Snow Shadows, c. 1916

In the winter of 1915–1916, as they became more friendly, Lawren Harris would have told Thomson of the excitement to be found in painting snow, since all the colours of the rainbow could be found in it. Immediately upon his return to Algonquin Park that spring, Thomson began to seek out snow subjects, partly for the colour to be found there, and also for the way snow clarified the design of the tree branches.

Oil on panel, 21.5 x 26.9 cm (8⁷⁄₁₆ x 10⁹⁄₁₆ in.)

McMichael Canadian Art Collection, Kleinburg

Gift of Mr. R.A. Laidlaw

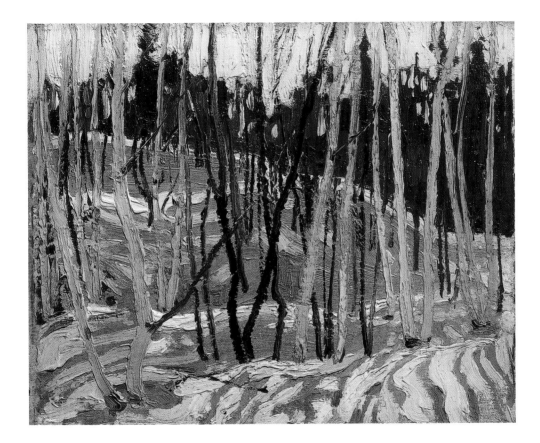

Purple Hill, c. 1916

Thomson began to paint trees on a rocky shore very early in his work. More than one friend recalled that they had seen the sketch for *The West Wind*. What they probably saw were sketches of trees on rocky shores, as here. In this sketch, Thomson gave the subject a simplified format, flat design, and elegant colour.

Oil on panel, 21.6 x 26.7 (8½ x 10½ in.)
McMichael Canadian Art Collection, Kleinburg
Gift of Mrs. H.P. de Pencier

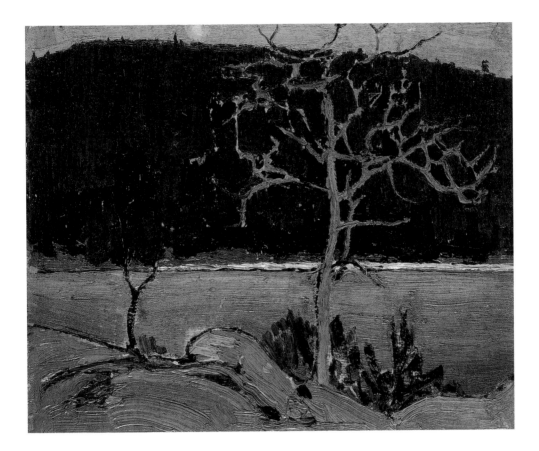

ALGONQUIN PARK, 1916

To gaze upon Thomson's unassuming oil sketches – simple interweavings of brushstrokes and coloured bands of land broken by the vertical shapes of trees – is to surrender to a fine visual hedonism. Thomson created his compositions using narrow brushes and oil paint. The process seems effortless, but to achieve such complex orchestrations of light, colour, and space required a trained eye. Up close, the trees look delicate, the scene, silent and still. Thomson especially valued this work: he gave it as a gift to a friend in the Studio Building, painter Arthur Heming. On the back he wrote the words "for ARTHUR HEMING FROM TOM THOMSON."

Oil on panel, 21.6 x 26.7 cm (8½ x 10½ in.)
Montreal Museum of Fine Arts, Montreal
Gift of A. Sidney Dawes, 1947

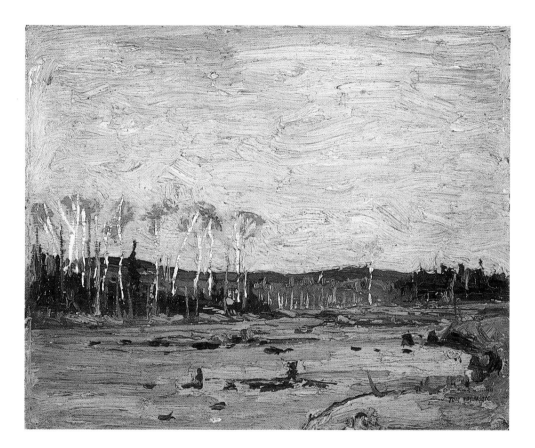

THE WEST WIND (SKETCH), 1916

From this sketch Thomson developed the great canvas now in the Art
Gallery of Ontario's collection. There are different stories about where
Thomson painted it. T.W. Dwight of the University of Toronto believed
he painted the sketch at Achray on Grand Lake, Algonquin Park; others
believe the sketch was painted farther north, possibly in Pembroke.
Winifred Trainor believed it was painted at Cedar Lake.

Oil on panel, 21.3 x 26.7 cm (8³/₈ x 10¹/₂ in.)

Art Gallery of Ontario, Toronto

Gift of the J.S. McLean Collection, Toronto, 1969

Donated by the Ontario Heritage Foundation, 1988

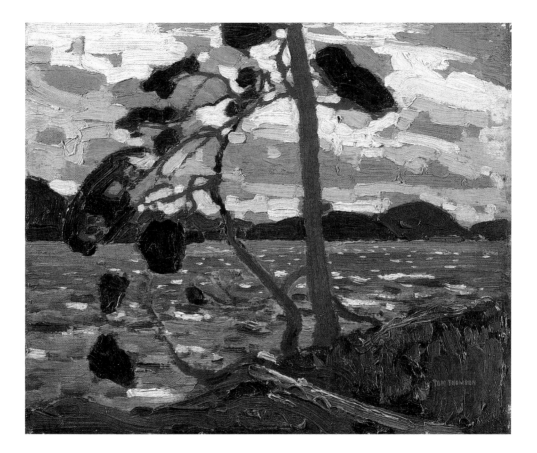

Pine Island, c. 1916

The McMichael Canadian Art Collection, which owns this sketch, dates
it as "1914," no doubt in the belief that it is a Georgian Bay sketch.
However, the sketch looks later to me. In the summer of 1916, Thomson
painted a number of strongly designed sketches, such as the sketch for
The West Wind. This sketch resembles those works: hence, my later
date. My reasoning includes the idea that there can be more than one
"pine island." If my dating is correct, this pine island would be in
Algonquin Park.

Oil on board, 21.6 x 26.7 cm (8½ x 10½ in.)
McMichael Canadian Art Collection, Kleinburg
Gift of the Founders, Robert and Signe McMichael

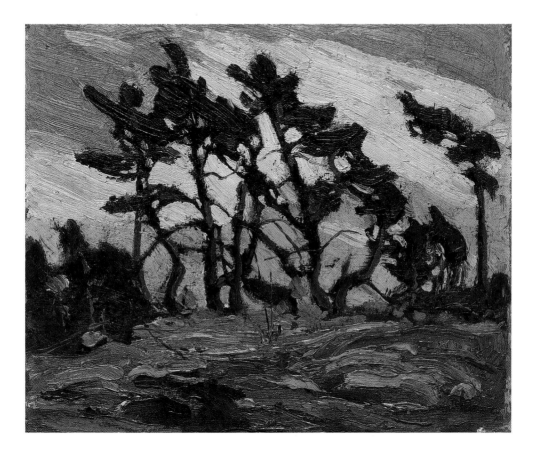

Ragged Pine, c. 1916

This dark sketch may have been painted on a rainy day in the Park. Like *The West Wind* sketch, Thomson didn't hesitate to use only part of the tree when it suited him.

Oil on panel, 21.5 x 26.7 cm (8⁷⁄₁₆ x 10¹⁄₂ in.)
McMichael Canadian Art Collection, Kleinburg
Purchased with funds donated by R.A. Laidlaw

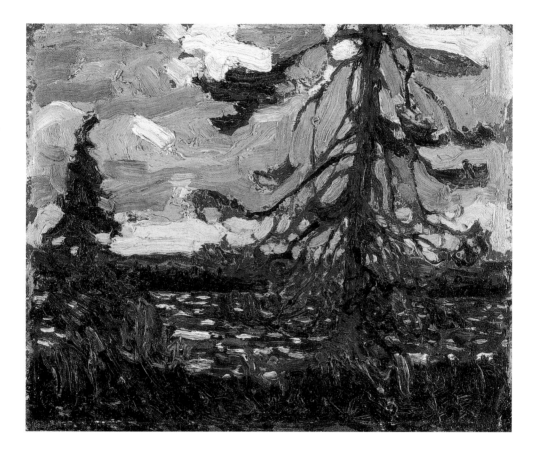

Ragged Pine, c. 1916

In this powerful and dramatic study of contrasting diagonals, Thomson
focused on the interlocking pattern of trees and sky.

Oil on panel, 21.3 x 26.2 cm (8³⁄₈ x 10¹⁵⁄₁₆ in.)
Private Collection, Toronto

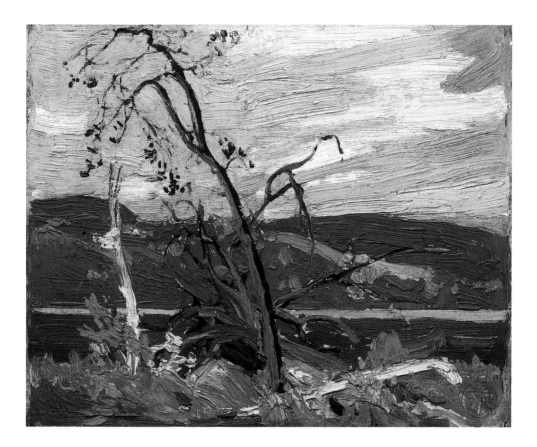

Nocturne, c. 1916

This sketch is one of Thomson's powerful tree subjects of 1916.

Oil on panel, 21.0 x 26.7 cm (8$\frac{1}{4}$ x 10$\frac{1}{2}$ in.)

Private Collection, Calgary

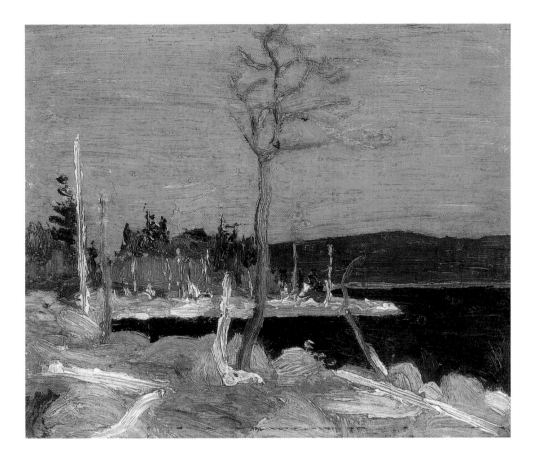

Ragged Oaks, c. 1916

On the verso of this sketch, one of Thomson's friends has written "Ragged Oaks/Not for Sale/16," which tells us the kind of tree Thomson painted in the sketch, the year [1916], and that the sketch was specially valued by his peers – hence, "not for sale." It belonged to Thomson's family.

Ten species of oaks grow in Canada. Identification of the variety Thomson painted is difficult. Certainly he was painting one of the rarer trees in Algonquin Park. The oak is characteristic of the Deciduous Forest.

Oil on panel, 21.4 x 26.7 cm (8⁷⁄₁₆ x 10¹⁄₂ in.)
Private Collection, Toronto

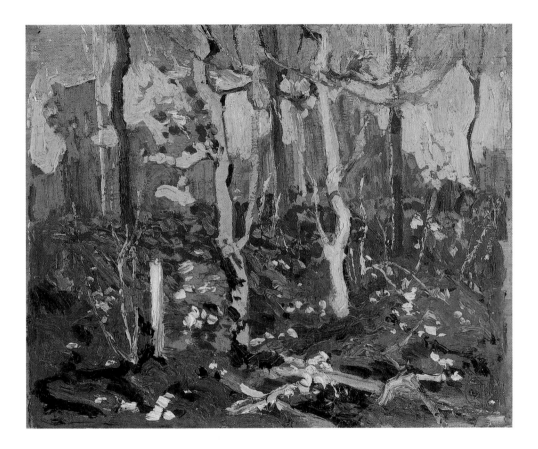

Algonquin, Autumn, c. 1916

In the fall of 1916, Thomson painted intensely colourful work that hovered on the borderline between abstraction and reality, often using the back of works he had painted earlier that summer. This painting was once the back of another work; the panel was separated by a conservator.

Oil on board, 26.7 x 21.6 cm (10$\frac{1}{2}$ x 8$\frac{1}{2}$ in.)
Private Collection, Calgary

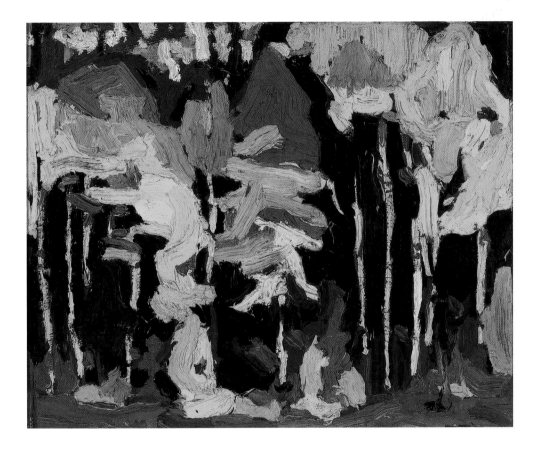

FOREST, OCTOBER, 1916

This small sketch is one of Thomson's most brilliant. In it, a basically abstract pattern derived from the branches of the forest combines with the tree shadows in a rhythmic dance. The intense colours and the resilient black make the enclosed and silent forest seem to burn with colour before the viewer's eyes.

Like other sketches painted in the heart of the forest that October, Thomson kept the effect from being claustrophobic by adding a touch of sky at the top. On a related sketch MacCallum wrote, "Thomson himself said this was only the most truthful of his sketches – 'the most light in it' were his words." The sky at the top of the sketch helped the effect of light.

Painter Lilias Torrance Newton once owned this sketch.

Oil on panel, 20.9 x 26.6 cm (8³/₁₆ x 10⁷/₁₆ in.)
Art Gallery of Ontario, Toronto
Gift of the J.S. McLean Collection, Toronto, 1969
Donated by the Ontario Heritage Foundation, 1988

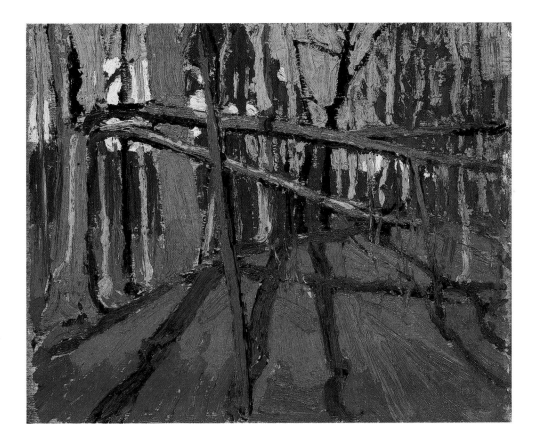

BEECH GROVE, C. 1916

The gallery that owns this work dates it "1915." However, its relation to
the previous work and the interesting zigzags of the composition suggest
a later date. *Autumn Birches*, the next work, was on its other side.

Oil on panel, 21.6 x 26.5 cm (8⁹/₁₆ x 10⁷/₁₆ in.)
McMichael Canadian Art Collection, Kleinburg
Gift of the Founders, Robert and Signe McMichael

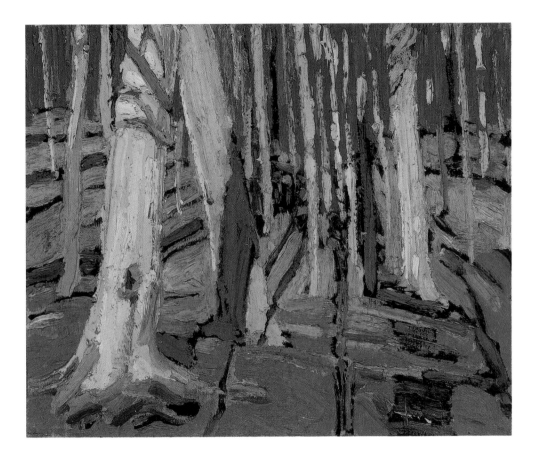

Autumn Birches, c. 1916

This admirable sketch reveals qualities common to all of Thomson's work. One is that the illusion he has created of an interpretation of nature is inevitable. Thomson's manipulations of colour and form, and his tendency to build strong structures that move by their serenity and intensity, are remarkably persuasive; one could forget, momentarily, that there are other ways to construct these scenes.

The second quality is the sheer clarity of Thomson's design. Individual forms are always in focus, but Thomson's often sharp accenting and careful balancing keep competing forms in perspective. The most striking aspect of his work though, is that a viewer has the sense of having seen a surprising route to a destination that has been in the plan all along.

Oil on panel, 21.6 x 26.7 cm (8 $\frac{1}{2}$ x 10 $\frac{1}{2}$ in.)

McMichael Canadian Art Collection, Kleinburg

Gift of Mrs. H.P. de Pencier

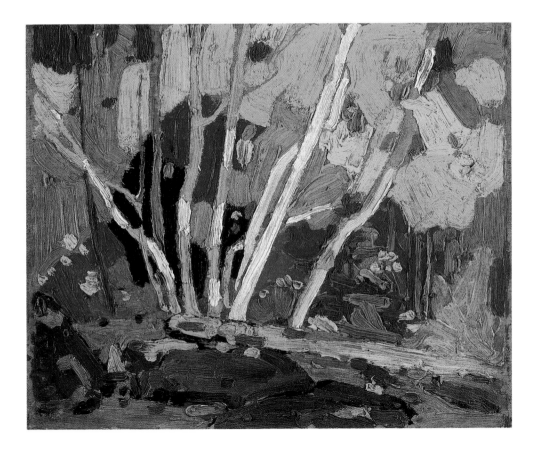

Red Sumac, c. 1916

In the sketch medium, Thomson employed an experimental technique, executed without preliminary studies. He always maintained a sense of relationship and contact with the surface of the support, often leaving areas of the surface uncovered in the final work to give the sketch room to breathe.

Oil on panel, 21.6 x 26.7 cm (8½ x 10½ in.)
Tom Thomson Memorial Art Gallery, Owen Sound
Gift of T.J.G. Henry

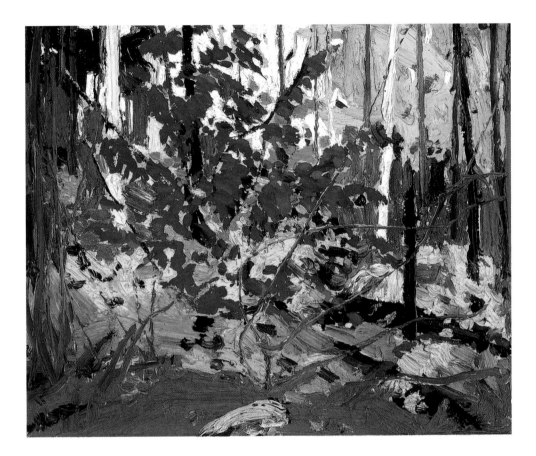

AUTUMN FOLIAGE, C. 1916

Thomson finished this carefully structured and spatially logical sketch more fully than usual. Note the contrast of the rich autumn foliage with the blue of the lake.

Oil on panel, 21.4 x 26.8 cm (8⁷⁄₁₆ x 10⁹⁄₁₆ in.)

Edmonton Art Gallery, Edmonton, Alberta

Gift of R.A. Laidlaw, Toronto, 1954

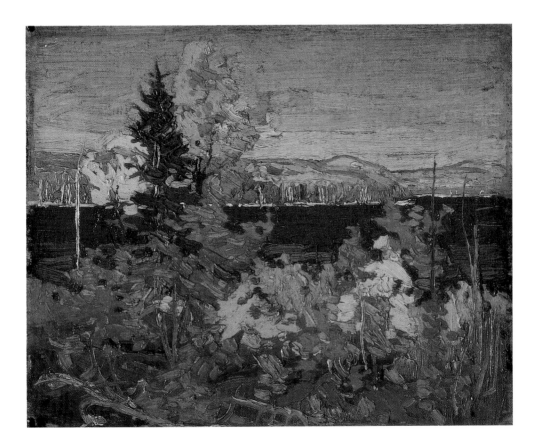

Autumn, Algonquin Park, c. 1916

On the back of this sketch, one of Thomson's friends — from the handwriting, perhaps Lawren Harris — wrote "*1st* class." The sketch helps define Thomson as a constant observer of outdoor life whose "boards," as he called them, were never far from reach.

Oil on panel, 21.6 x 26.7 cm (8½ x 10½ in.)
Private Collection, Toronto

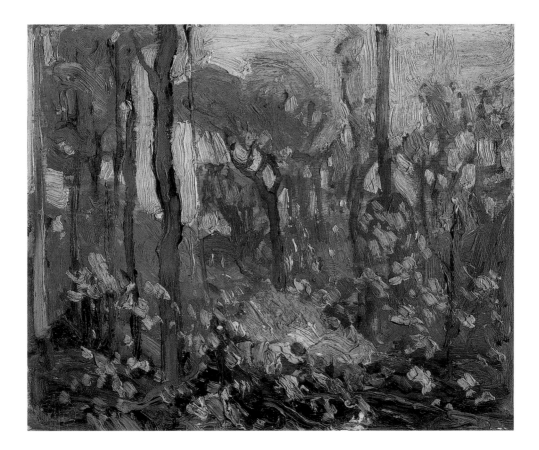

Autumn, Algonquin Park, c. 1916

A colourist first and foremost, Thomson's paintings look simple but the shapes are cleverly balanced, sometimes layered horizontally or pushed against one another vertically. The colours are fresh and lively: the blacks are tempered by greys. Other shapes are detectable by close looking.

Oil on pressed board, 21.6 x 26.7 cm (8 ½ x 10 ½ in.)
Private Collection, Calgary

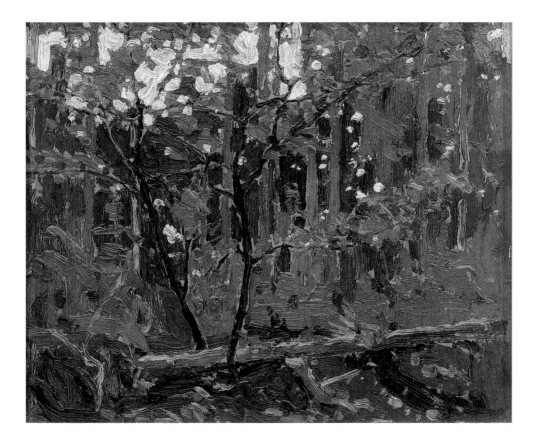

Autumn Foliage, c. 1916

Thomson's way of working in an open network of dots and dashes that seems to form a screen of colour was boldly experimental. Even today, sketches such as this one with its flat design, strong colour, and simplified form looks contemporary.

Oil on wood, 26.7 x 21.5 cm (10½ x 8⁷⁄₁₆ in.)
National Gallery of Canada, Ottawa
Purchased, 1918

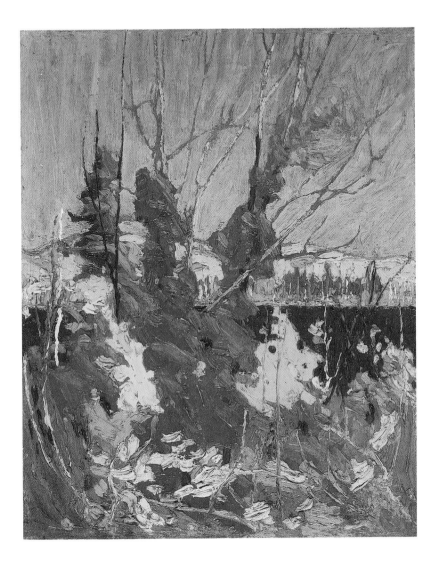

EARLY WINTER GROWTH, C. 1916

The rich pattern of trees and central rock is a testament to Thomson's enduring interest in design.

Oil on panel, 26.7 x 21.6 cm (10½ x 8½ in.)
Private Collection

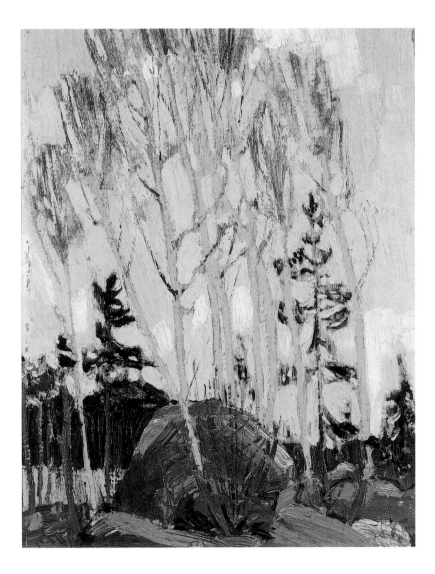

THE BIRCH GROVE, AUTUMN,
C. 1916–1917

This painting, with its almost square format, reflects the influence of Lawren Harris on Thomson. Harris, in turn, may have attained the format from the American painter Childe Hassam. Certain areas of the painting technique such as the bold, summary strokes Thomson applied to the rocks, also recall Harris. At this date, Harris had been strongly influenced by the stitch technique – juxtaposing thick strokes of complementary hues – used by the Swiss painter Giovanni Segantini. Perhaps he was inspired in part by reproductions in the magazine *Jugend* or through exhibitions of Marsden Hartley at Steiglitz's 291 gallery in New York (Hartley cited Segantini and his stitch stroke as his first direct influence). The shadow of the tree in the foreground (the tree itself is in the viewer's world) is a detail Thomson took from the work of A.Y. Jackson. What was indelibly his own was his feeling for the structure of the land. The slope of the hill is well established, as is the screen of trees in the background. From a distance the strokes mesh into shapes.

The sketch for the canvas *Birches* in the National Gallery of Canada, Ottawa, is much earlier in date (1914). As usual in his translation of sketch to canvas, Thomson exaggerated the hillside to give the picture greater depth.

The bold handling and use of contour lines in this painting are also found in *The Jack Pine* and *The West Wind*. All three indicate Thomson's direction. He seems to have been trying to add depth to the flat, decorative treatment he had used earlier in his canvases.

Oil on canvas, 101.6 x 116.8 cm (40 x 46 in.)

Art Gallery of Hamilton, Hamilton

Gift of Roy C. Cole in memory of his parents, Matthew and Annie Bell Gilmore Cole, 1967

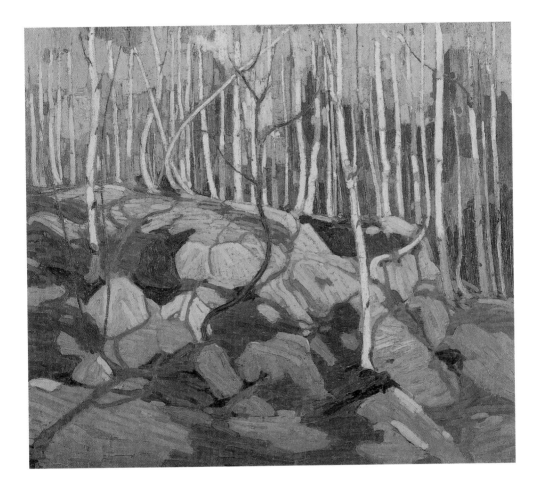

THE JACK PINE, C. 1916–1917

Thomson wanted to evoke the power of the North in a picture. His was a new aesthetic that, through its simplified shapes, powerful contour lines, and bold use of colour, foretold the advances of modernism in the twentieth century.

For the motif in this painting, Thomson used a sketch he had painted, probably at Carcajou Bay on Grand Lake in Algonquin Park, but he emphasized and simplified the tree to create this strongly designed painting. From Harris, as with other canvases of this season, he took the almost square format and broad handling (some of the strokes of paint are five to eight centimetres long). "Harris's patent sky," is what MacCallum called it in another work.

One feature – the vermilion undercoat that lies beneath the layers of paint on the tree, hills, and foreground rocks – is pure Thomson and may have come from his training in commercial art. Whatever the source, Thomson's intention was to make the tree stand out from the background.

On rocky sites, the Jack pine can be short, often twisted, with wide-speading, lightly foliaged branches that give the crown an unkempt appearance. It grows on slopes where few other pines will venture. The bark is reddish-brown to grey on young stems, becoming dark brown and flaky, which may also account for Thomson's use of a red undercoat.

The general effect is vigorous and vital, and the canvas does look like a harmonious whole. Thomson, however, seems to have been unhappy with the painting. He was troubled by the sky, said Jackson, and he re-worked the background.

Oil on canvas, 127.9 x 139.8 cm (50⅜ x 55 in.)
National Gallery of Canada, Ottawa
Purchased, 1918

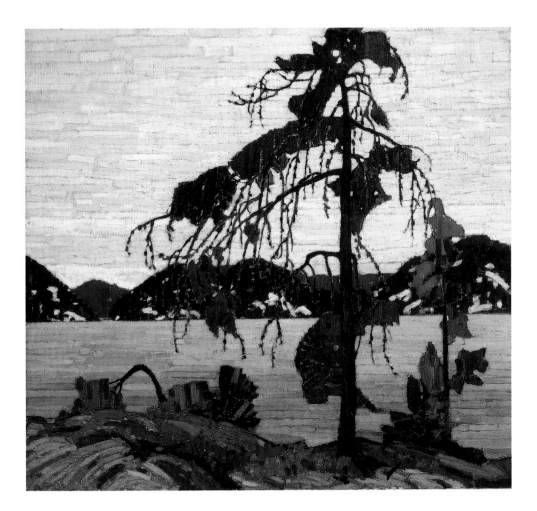

THE WEST WIND, 1917

Arthur Lismer felt that the trees in this painting are a symbol of our Canadian character; the pines that refuse to yield to the wind are an emblem of steadfastness and resolution. Lismer found poetry in the painting's imagery – the two trees like the "harp of the wind" flung across the composition.

Thomson developed the canvas from one of the tree sketches he had been painting since 1914.

Winifred Trainor recalled that in 1917, when he went north, he was unhappy over the painting. The "stained glass" handling of the leaves of the trees, hills, and in the rocks of the foreground – the use of large blocks of colour – are not in harmony with the more atmospheric treatment of the sky. However, since it has become an icon of Canadian art, few notice any discordant qualities in the work.

Though the subject had long been a favourite of American art, Thomson created his own distinctive version.

Oil on canvas, 120.7 x 137.2 cm (47½ x 54⅛ in.)
Art Gallery of Ontario, Toronto
Gift of the Canadian Club of Toronto, 1926

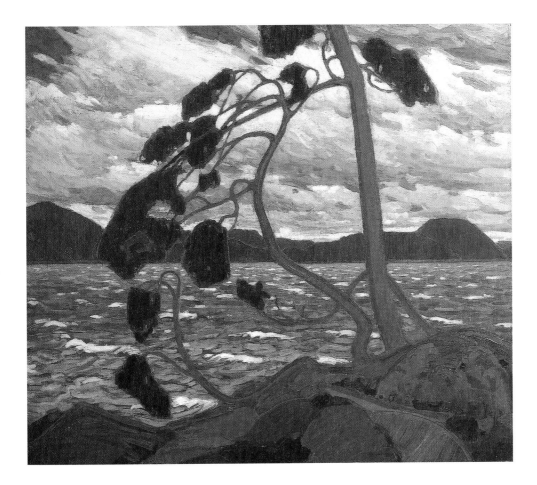

BIRCHES, C. 1917

In the spring of 1917, Thomson started a series he believed to be unique – "a record of the weather for 62 days, rain or shine, or snow, dark or bright." Sometime during that spring, he destroyed or, short of painting materials, reused about one-third of the sketches. This sketch was part of the series. It was painted on wood recycled from a wooden crate that possibly held Purity Flour or oranges.

Oil on panel, 14.5 x 20.0 cm (5 $^{11}/_{16}$ x 7 $^{7}/_{8}$ in.)
Tom Thomson Memorial Art Gallery, Owen Sound
Gift of Mrs. J.G. Henry

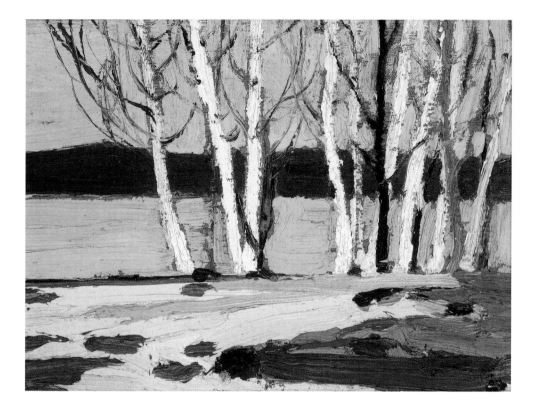

An Ice Covered Lake, 1917

The wood of this sketch was, as with *Birches*, recycled from a packing case.

Oil on panel, 13.3 x 19.1 cm (5 ¼ x 7 ½ in.)
Tom Thomson Memorial Art Gallery, Owen Sound
Gift of George Thomson, 1967

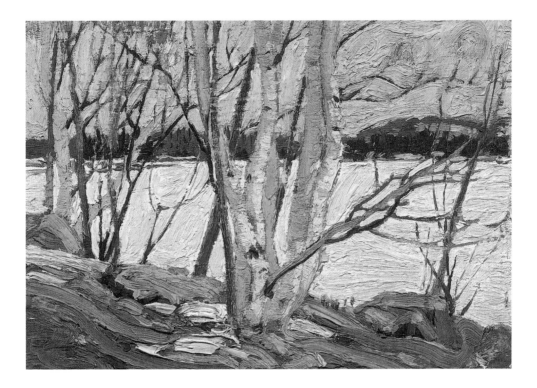

Snow and Earth, 1917

This is another of the tiny panels Thomson painted during the last spring of his life.

Oil on wooden panel, 12.5 x 18.5 cm (5 x 7¼ in.)

Tom Thomson Memorial Art Gallery, Owen Sound

Loan from the Ontario Heritage Foundation, Estate of Thomas James Gibson Henry

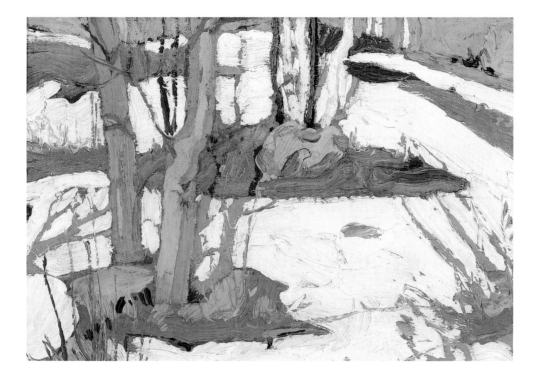

Spring Breakup, c. 1917

This sketch is remarkable for its quality of movement, and proof that if Thomson had lived he would have been as his friend J.E.H. MacDonald believed, the "grand old man" of the school that in 1920 became the Group of Seven.

He would have sought new painting sites, such as the Rockies, since, as he wrote a brother-in-law in April 1917, he hoped to go West in July. A.Y. Jackson said that Thomson would have even travelled farther north, perhaps up to the Alaska Highway, like other members of the Group of Seven. Everywhere he went, Thomson would have carried his unique ability to absorb a landscape down to its basics and to convey its individual self. Everywhere he went, he would have sought out trees to paint.

Oil on panel, 21.4 x 26.7 cm (8⁷/₁₆ x 10½ in.)
Private Collection, Montreal

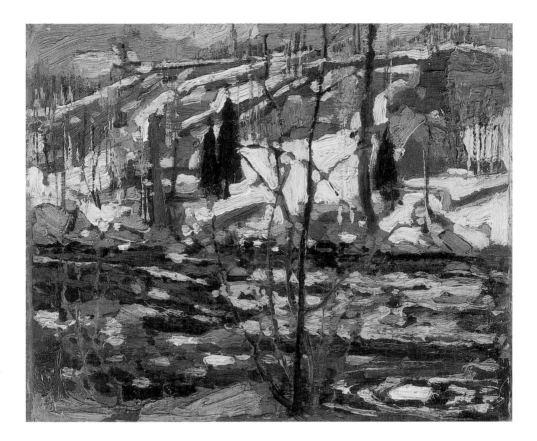

Further Reading

It would be impractical to present a complete bibiliography of the literature that has appeared about Tom Thomson. This is a selection relevant to the theme of this book or of value to the general reader.

Addison, Ottelyn, and Elizabeth Harwood. *Tom Thomson, Algonquin Years* (Toronto: Ryerson Press, 1969).

Killan, Gerald. *Protected Places: A History of Ontario's Provincial Parks System* (Toronto: Dundurn Press, 1993).

MacKay, Roderick, and William Reynolds. *Algonquin* (Toronto: Stoddart / Boston Mills Press, 1993).

Murray, Joan. *The Best of the Group of Seven* (Edmonton: Hurtig Publishers, 1984; reprint Toronto: McClelland & Stewart, 1993).

———. *The Best of Tom Thomson* (Edmonton: Hurtig Publishers, 1986).

———. *Northern Lights: Masterpieces of Tom Thomson and the Group of Seven* (Toronto: Key Porter, 1994).

———. *Tom Thomson: The Last Spring* (Toronto: Dundurn Press, 1994).

———. *Confessions of a Curator* (Toronto: Dundurn Press, 1996).

———. *Tom Thomson: Design for a Canadian Hero* (Toronto: Dundurn Press, 1998).

Reid, Dennis. *The MacCallum Bequest* (exhibition catalogue) (Ottawa: National Gallery of Canada, 1969).

———. *Tom Thomson, The Jack Pine: Masterpieces in the National Gallery of Canada*, no. 5 (Ottawa: National Gallery of Canada, 1975).

Town, Harold, and David P. Silcox. *Tom Thomson: The Silence and the Storm*, 2nd ed. (Toronto: McClelland & Stewart, 1982).

Illustration Credits

ACKNOWLEDGEMENTS

In 1970, I began work on Tom Thomson. Shortly after I began, I thought of interviewing the Thomson family. I spoke with Thomson's youngest sister, Mrs. Margaret Tweedale, among others. She helped me with many insights, most notably with the information that Thomson had collected specimens for Dr. William Brodie. She mentioned the point when I interviewed her about the photographs Thomson had taken himself. Much later, in preparation for one of my books, *Tom Thomson: The Last Spring* (1994), I researched Dr. Brodie in the library archives of the Royal Ontario Museum, Toronto, where from 1903 until his death in 1909 he had served as the director of the Department of Biology. Since then, I have attempted to see Thomson's work through his own eyes, the eyes of a Brodie-trained man – hence, this book. Thomson, it seems to me, was assembling trees in some vast record in his head. We have the pleasure of seeing some of the works from the "collection" he made in the time permitted to him.

I would like to thank the following dealers who assisted with obtaining colour transparencies: Rod Green of Masters Gallery Ltd. in Calgary, John Libby of Libby's of Toronto, and Eric J. Klinkhoff of Galerie Walter Klinkhoff Inc., Montreal.

Joan Murray,
Oshawa

The main text is set in Monotype Fournier. It is a Transitional, or Neo-Classical typeface, originally
designed c. 1740 by Pierre Simon Fournier, Paris. It was recut and released in 1926 by Monotype,
England. The credits are set in FFMeta, designed 1985–91 by Erik Spiekerman, Berlin.
Film and separations by Quadratone Graphics, Limited.
Printed by Friesen Printers.
